This is
Bacon

Published in 2014 by
Laurence King Publishing
361–373 City Road
London EC1V 1LR
United Kingdom
T +44 20 7841 6900
F +44 20 7841 6910
enquiries@laurenceking.com
www.laurenceking.com

A catalogue record for this book is available
from the British Library.

ISBN: 978 1 78067 185 7

Series editor: Catherine Ingram

Printed in China

This is
Bacon

KITTY HAUSER
Illustrations by CHRISTINA CHRISTOFOROU

LAURENCE KING PUBLISHING

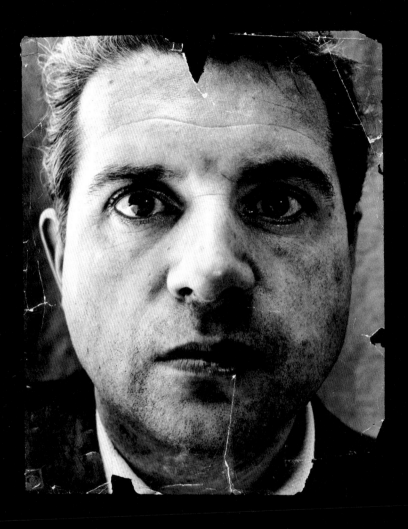

Portrait of Francis Bacon
John Deakin, 1952

Gelatin-silver print
Victoria and Albert Museum, London

By all accounts, **Francis Bacon** had an effect on those he met. He didn't look like other people, didn't talk or act like them. 'It's all so meaningless,' he liked to say, 'we may as well be extraordinary.' His paintings continue to have an effect on those who see them. They have the capacity to move us, without it being possible to say why. They convey something of how it feels to be a human – King Lear's 'poor, bare, forked animal'.

Sometimes they do. Sometimes they don't work at all. Bacon realized he walked a tightrope of success and failure with every brushstroke, and with every work. He destroyed a lot of paintings. He was aiming high, after all. Answering what he called 'the long call from antiquity', he wanted his work to keep company with the Old Masters he revered, but his methods were unusual and his training minimal. 'My work will either end up in the National Gallery or the dustbin,' he used to say.

The Eyes and the Grinding-Up

Bacon's training took place not at art school, but through the voraciousness of his eye, and the extremity of his experiences. He liked to observe human behaviour, especially when it was governed by instinct rather than convention. His relative lack of a formal education meant that he did not make the usual kinds of distinctions between life and art, or between high culture and low. His mind and his studio were well stocked with images from a multitude of sources – cinema, medical literature, art galleries, everyday life – and some of these images inevitably found their way, sometimes consciously, sometimes unconsciously, into his paintings. 'Don't forget that I look at everything', he said. 'And everything I see gets ground up very fine. In the end one never knows, certainly I myself never know, what the images in my paintings are made up of.'

Bacon collected images, which formed an ever-thicker layer on his studio floor: reproductions of Old Master paintings, pages from the photographic news magazine *Picture Post*, photos of big game hunting, medical imagery. He was drawn to what the critic John Russell called 'the prehensile image'; images that stick, that hold on. He used them not so much as references (something to copy) but as triggers for ideas. For Bacon, images were both promiscuous and fertile; they sparked off each other in unexpected ways. 'Images breed images in me', he was fond of saying. Putting them next to each other created possibilities. Bacon's entirely natural (yet highly unusual) refusal to differentiate between the value of high art and the images of mass culture meant that, in a sense, he could see them all more clearly. He wanted his own work to combine the immediacy and shock of news images with the permanence of the Old Masters.

The Sylvester Interviews

Much of what is said about Bacon and his work derives from a series of recorded conversations he had with the art critic David Sylvester. Artists are not always good at putting what they do into words. But Bacon had a talent for talking, and provided some of the best things ever articulated about art and the impulse to make it, straight – as it were – from the horse's mouth.

Despite his eloquence, Bacon always insisted that his pictures could not be explained. If they were reducible to words, there would be no point in painting them. They would be no more than illustration, a word he used a lot, as if by repeating it with disdain he would avoid falling into its trap. But Bacon did have a lot to say about what painting is, and what it should do to the viewer.

Painting is a struggle, he said, much concerned with chance. Sometimes it works, but often it doesn't. Successful paintings are those which 'open up the valves of sensation', the ones that bypass the intellect and go straight to 'the nervous system'. Bacon wanted his paintings, like Greek tragedy, to 'return the onlooker to life more violently'. And he wanted this to happen through the operation and effects of the painted image, not through any kind of narrative, symbolism or interpreted meaning. The challenge was to be as 'factual' – as he put it – as possible, without resorting to illustration. The 'fact' has to be trapped, like a wild animal. This is a very uncertain process, but it is more likely to happen when the painter is not fully conscious of what he is doing. He is a conduit, not a creator. The paintings that work best, Bacon believed, are those that are unexpected.

Irish Childhood

Francis Bacon was born in Dublin in 1909. His Australian-born father was an ex-military man with vague claims to an aristocratic lineage, while his mother was from the north of England, and heiress to her family's steel business. Eddy Bacon used his wife's money to set himself up as a trainer and breeder of racehorses; it was this that brought the family to Ireland. Francis was the second of five children. He remembered his childhood taking place in a series of big houses in England and Ireland, their often grand architectural spaces – especially a distinctive interior curved wall – finding their way into his paintings much later. His schooling was sporadic. The eccentricity of some of his relations was a normal part of his early life; so, too, were the animal facts of life (his father was a horse-breeder after all). Eddy Bacon expected his sons to be tough; unfortunately for him, young Francis was not. He suffered badly from asthma – a condition that was more serious before the ready availability of medication – and the family stables made it worse.

For a man who liked to talk, Bacon was curiously quiet about his childhood. On the rare occasions he spoke about Ireland he would become afflicted again by asthma; he was never able to board a plane going there. Odd remarks would break out with a jocularity that belied the abuse he described. 'My mother and father were disgusted with me', he told an interviewer with a cheerful grin. He told a friend that he had been whipped by the stable grooms at his father's verging-on-kinky request. He lived in an atmosphere of threatened violence, both inside and beyond his own domestic world. He remembered lying in bed as a child and hearing the British cavalry carrying out manoeuvres on the Curragh Plains; his father was so conscious of the threat of the newly formed Sinn Fein that he told his children to keep quiet if they ever came for them, or came to steal his horses. His grandmother, who was married to the head of police in Kildare, had sandbagged windows, and to the end of her days his mother would not sit with her back to an uncurtained window.

When Francis was sixteen, he said, his father discovered him dressing up in his mother's underwear, and he was banished from the family home. It's a story of mortification and rejection, and it seems to have scarred the young man with a visceral sense of guilt and exile, which he later saw reflected in Greek tragedy; a sense that nothing, after some obscure crime, would ever be the same again. But it also surely seeded in him a sense of the absurdity of bourgeois life, with its arbitrary conventions, its accoutrements and its hypocrisies. All his life Bacon would maintain this outlook, seeing duchesses, soldiers, priests and himself as taking part in a kind of theatre we call civilized society. And all his life he liked to wear women's stockings.

Berlin

Ejected from his family home, Bacon went to London with three pounds a week from his mother. He was young, and – as he later confessed – not very moral. He was taken out by older men, and found that he did not have to do much to live the life he wanted. He got by on petty theft and rent-dodging when he was not being wined and dined. Sometimes he took up odd jobs in domestic service, and was usually swiftly fired.

It was ostensibly with the idea of 'straightening out' his son that his father put him into the hands of a horse-breeding 'uncle' who was rather brutal. Is it possible that Eddy Bacon did not know what kind of man he was? The uncle took Francis to Berlin, described by the poet W. H. Auden in those years as 'the bugger's daydream'. They stayed at the Hotel Adlon. It gave the young Bacon an experience of decadent luxury; he remembered a silver breakfast trolley with a swan's neck at each corner that he would pull over to the four-poster bed the two men shared. This luxury was thrown into relief by the poverty he saw on the streets. These were the years of the Weimar Republic, in which cultural and sexual liberation coincided with hyper-inflation and unemployment after World War I. It was a brief period of experimentation and squalor, brought to an end by the Nazis, whose thugs, in 1927, were already lining up.

Berlin was a wonderful, terrible place in these years, a 'Babylon of the modern world' in the words of novelist Stefan Zweig. Every perversion was catered for. There were cross-dressing cabarets and transvestite shows whose flamboyance and inventiveness have never been matched. There was inventiveness in art and design, too: the Bauhaus school of design, and the so-called 'New Objectivity', a clear-eyed and politically disruptive depiction of reality, in painting, photography and film. But the young Bacon had not much interest in art. When he was not in bed at the Adlon, he wandered the streets, paying attention indiscriminately (as drifters do) to what was around him, from *tableaux vivants* advertising nightclubs to the antiquities at the Pergamon Museum. This drifting suited him, and when his equally indiscriminate 'uncle' got bored of him and went off with a woman, Bacon went to Paris with no fixed plan.

Paris

It wasn't long before Bacon had landed on his feet in Paris. He was taken in by a Madame Bocquentin, who had a house near Chantilly, not far from the capital. She took him under her wing, and a close friendship developed between them. She taught him French, and he accompanied her to galleries and events in Paris. For a young man who had, by his own account, been 'completely corrupted' by his experiences in Berlin, he had clearly managed to preserve a certain innocence in his demeanour; or perhaps he had just learnt how to behave in different social circles. To Madame Bocquentin's daughter, who was five at the time, their unusual lodger seemed like an angel, with his round face and enormous eyes; he was, she said, so very quiet.

It was in these impressionable years that Bacon was exposed willy-nilly to the images that would form his artistic imagination, from the Old Masters to the avant-garde. Surrealism in France was still fresh, as was the experimental work of the great Soviet film-makers; Berlin and Paris were the places to see them. Bacon watched Sergei Eisenstein's 1925 film *Battleship Potemkin*, becoming obsessed by the figure of the nurse in the famous Odessa Steps sequence, with her silently screaming mouth and her broken glasses. Later he saw the 1929 surrealist film *Un Chien Andalou* by Luis Buñuel. Surrealism championed the role of chance, the found object, the realm of the irrational; it proclaimed that 'beauty will be convulsive or it will not be'. In his magazine *Documents*, Georges Bataille published photographs of abattoirs, screaming mouths and big toes. It was a question of dissolving bourgeois values, bourgeois distinctions between rational and irrational, human and animal, civilized and barbaric; values and distinctions which, after all, could hardly survive in the wake of the brutality of World War I.

Bacon knew about brutality – he'd experienced it at home and at the Hotel Adlon – and he was excited by everything he saw. But it was, he said, the work of Picasso that made him think he might himself try to become a painter. Picasso was Bacon's great hero. He liked Picasso's biomorphic figures from the late 1920s, those distended and distorted bodies cavorting on a beach, or – in an image which for Picasso had strong sexual connotations – opening a door with a key. Bacon started to make drawings himself, occasionally attending classes in Paris. Few, if any, of these early drawings survive. Bacon's official career as an artist had not yet begun.

Still from the film *Battleship Potemkin*, by Sergei Eisenstein, 1925.

Bather Opening Door with Key, Pablo Picasso, 1927
Charcoal drawing, Musée Picasso, Paris

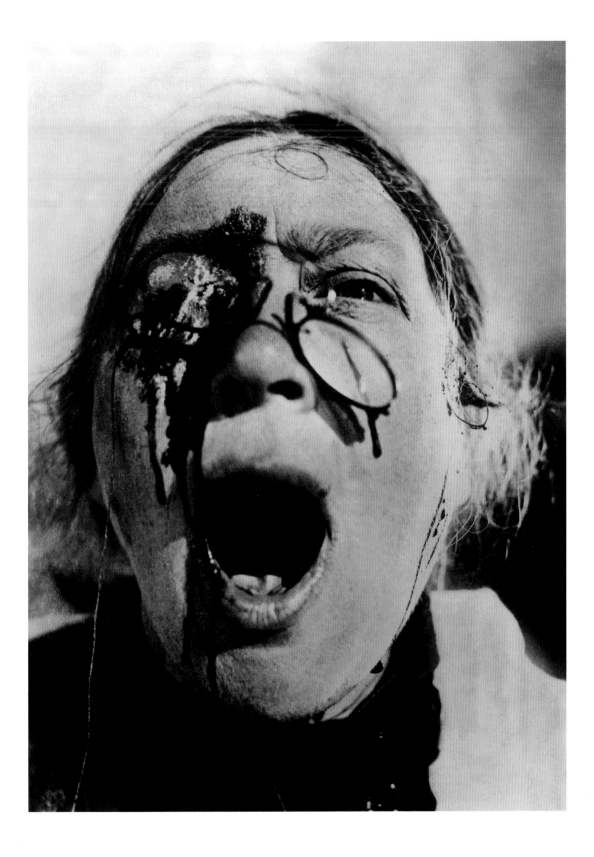

Eric Hall and the War

Bacon's domestic life remained unsettled as he moved from address to address. One constant fixture was his old nanny, Jessie Lightfoot, who continued to live with him until her death in 1951. Under the pseudonym 'Francis Lightfoot', Bacon advertised his services on the front page of *The Times* as a 'gentleman's gentleman'. This was homosexual soliciting coded as valeting, and Bacon's nanny used to vet the many replies that he received, 'and pick out the best ones'. When things got really bad, Nanny Lightfoot would go out shoplifting.

It was during a stint manning the phones at a London gentleman's club – another strategy for meeting rich men – that Bacon made the acquaintance of Eric Hall, a well-educated businessman and patron of the arts. Hall, in a sense, saved Bacon from the criminal life towards which he was heading. Not only did he pay his – and his nanny's – rent, he encouraged him to paint and promoted his work. He also broadened his cultural horizons, introducing Bacon to Greek tragedy and to the poetry and plays of T. S. Eliot. Bacon lapped it all up. Images and language from Aeschylus and Eliot would feed his imagination for years. Hall was married with children; it was surely a measure of Bacon's charisma that in 1936 Hall left his wife and family to be with him. He moved in with Bacon and Nanny Lightfoot in a remarkably odd ménage that nevertheless gave Bacon some stability for many years.

Bacon's asthma prevented him from being conscripted when war broke out in 1939. During the Blitz he worked for a while with Air Raid Precautions but as his breathing got worse he went to stay near Petersfield in Hampshire. He professed not to enjoy being in the country ('all those things singing outside the window'), but it was around this time that he began to be more serious about painting. 'If I hadn't been asthmatic,' he said, 'I might never have gone on painting at all.'

In 1943 he returned to London, taking up residence at Cromwell Place in South Kensington. The house had formerly belonged to the Pre-Raphaelite painter John Everett Millais; it had what one of Bacon's friends called 'an air of diminished grandeur'. Bacon survived what remained of the war by gambling. He worked in his splendid studio during the day, and at night hosted an illegal casino there.

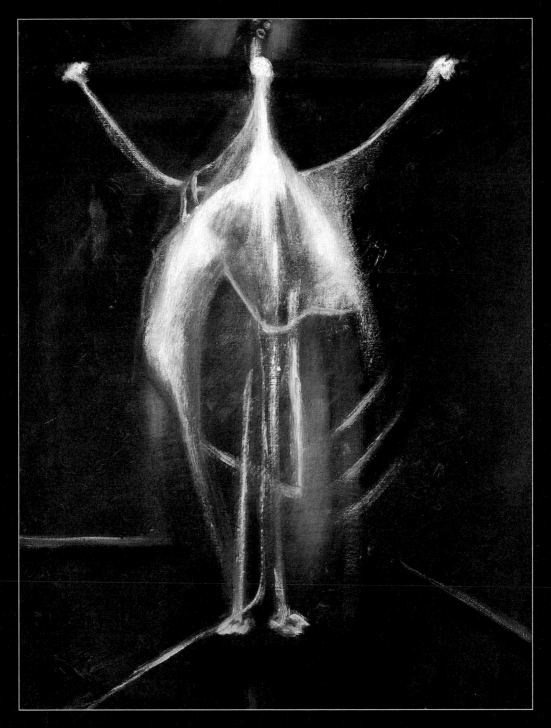

Crucifixion
Francis Bacon, 1933

Oil on canvas, 62 x 48.5 cm (24⅛ x 19⅛ in)
Private collection

De Maistre

At this point Bacon was spending a lot of time with the Australian artist Roy de Maistre, a fairly successful painter who had worked as an interior designer as well. Bacon learnt a lot from him about painting, and through him he also started to meet artists, writers and collectors.

Information about Bacon's first shows, and what was in them, remains hazy. In 1930 he exhibited some rugs and paintings alongside de Maistre and another artist called Jean Shepeard in his studio-cum-showroom, but we don't really know what most of the exhibited works looked like. They were either lost or destroyed. A surviving gouache from 1929 is much like the rugs and screens from the same year – standardly modernist and geometric in design with neo-classical motifs. Other works from the '30s – both confirmed and disputed – are so stylistically dissimilar that it is difficult to say what trajectory, exactly, the young artist was taking.

Bacon got his first real break when a painting of his called *Crucifixion* was included in Herbert Read's influential book *Art Now* (1933). *Crucifixion* shows a ghostly white pin-headed figure – perhaps two – against a dark background. In Read's book it was flatteringly coupled with a 1929 work by Picasso. De Maistre (who would later convert to Catholicism) was also painting crucifixion imagery at this time. Bacon's painting was bought by the influential Leeds collector Michael Sadler (it's now owned by Damien Hirst), and he commissioned another work, *The Crucifixion* (1933), which incorporated an X-ray of Sadler's skull.

It looked like the young artist might be going somewhere, as he gave up furniture design, and mounted his first one-man show in 1934. It was one of many false starts, however. After a not-very-favourable mention in *The Times*, Bacon destroyed all of the works in the exhibition (apart from the few that had been sold). He abandoned painting altogether for a while, receiving a further knockback when his work was rejected by the organizers of the 1936 International Surrealist Exhibition on the grounds that it was 'insufficiently surreal'. Very few paintings by Bacon before the mid '40s survive (although his rugs occasionally surface in auction rooms); his artistic output was sporadic, to say the least, and he destroyed or denied the existence of most of the works he did produce. He showed three paintings in an exhibition in 1937, but apart from this did not exhibit at a commercial gallery until 1945.

The 1930 Look

Bacon stayed in Paris until the end of 1928. How it was that less than a year later he launched himself – with some success – as an interior designer in London remains unclear. He was barely twenty. It is a brief episode in the young artist's life that might have remained hidden were it not for a feature in *The Studio* magazine entitled 'The 1930 Look in British Decoration'. Bacon is introduced hyperbolically as 'a young English decorator who has worked in Paris and in Germany for some years and is now established in London.' The text describes how Bacon transformed a garage into a modish space for living and working, with windows 'curtained with white rubber sheeting'. Photographs show the young designer's Queensberry Mews studio – we don't know how he afforded it – minimally kitted out with chrome, glass and tubular steel furnishings, a large circular mirror, and rugs all designed by him.

Bacon later discounted his early forays into interior design as derivative. And, to be sure, his tables, chairs, painted screens and rugs are pitch-perfect in their rendition of the sort of modern taste showcased in the pages of the *Architectural Review*. This was continental modernist style, borrowed from Paris and Berlin (and here Bacon's time in those cities gave him just the right credentials). The look is rational, clean and hygienic.

'The 1930 Look in British Decoration', from the August 1930 issue of *The Studio*.

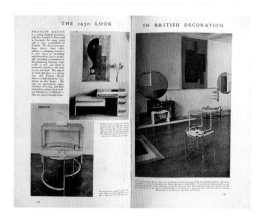

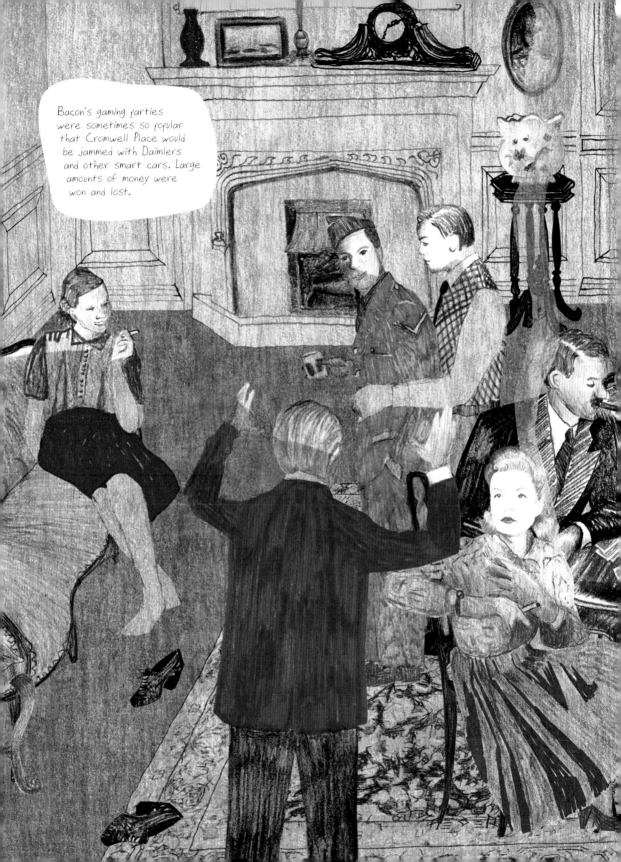

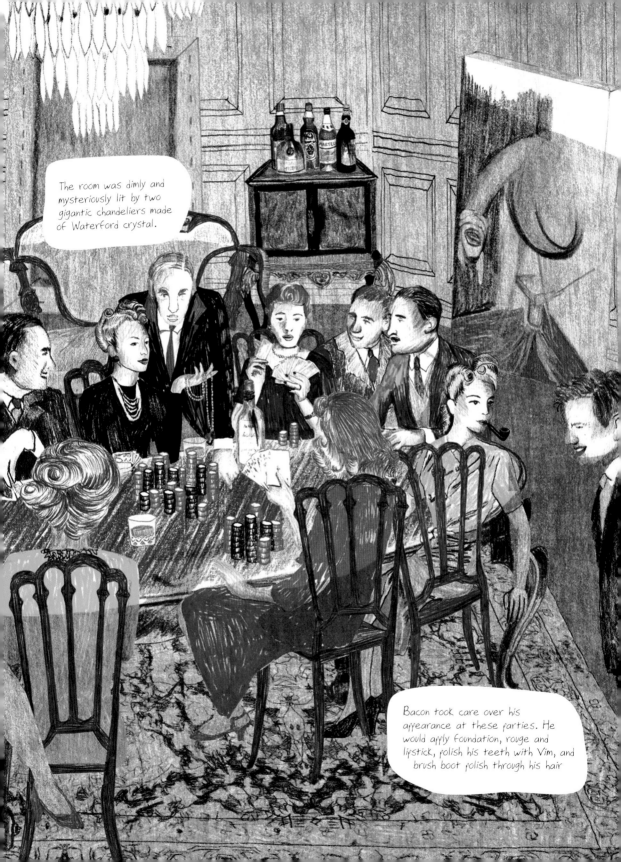

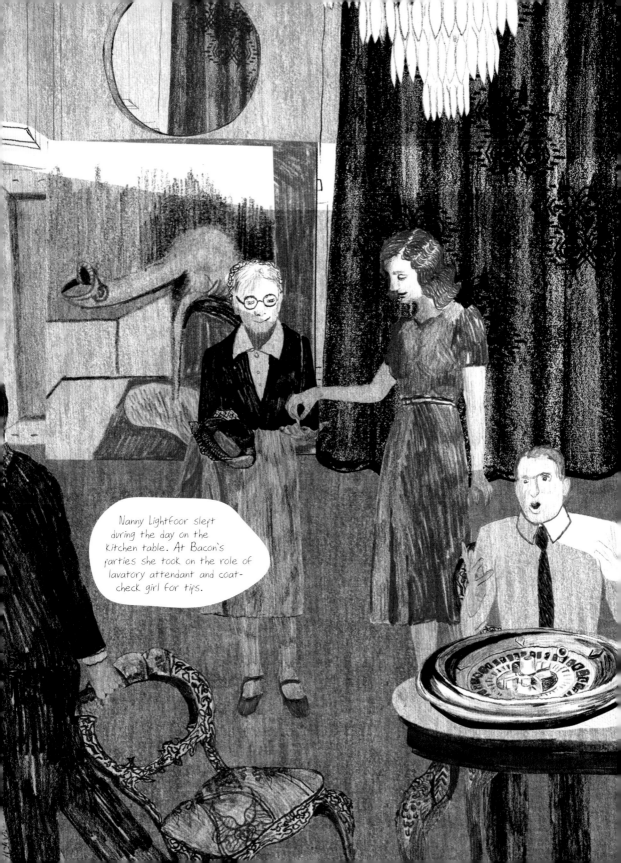

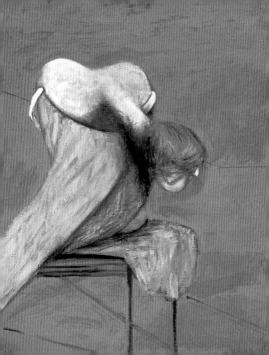

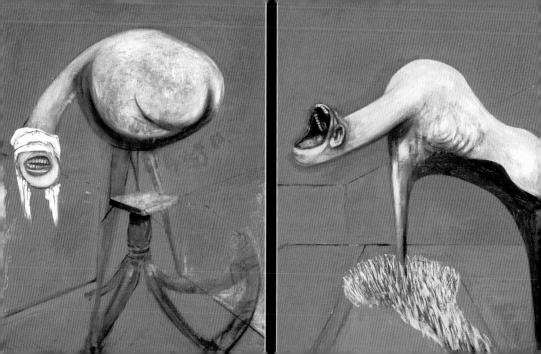

Three Studies

Three Studies for Figures at the Base of a Crucifixion was completed in 1944 and exhibited in a group show in London in the spring of the following year. It horrified just about everyone who saw it, and it made Bacon's name as a painter. In the words of the critic John Russell (who was there) these were 'images so unrelievedly awful that the mind shut with a snap at the sight of them'. 'We had no name' for these creatures, he wrote, 'no name for what we felt about them.'

Here were three figures, too human to be entirely animal, all blind limbless instinct, like leeches; wounded, disabled, toothy, weird, they seem to be preparing to lash out at whatever it is that threatens or comes near them. They are both base and artificial, penis-like mounds of flesh propped up on little platforms, cut-outs against an orange background recalling both fiery lust and the paintings of Degas. They stand at the foot of an unseen crucifixion, in the place occupied by saints or the grieving mother in traditional representations of Christ on the Cross. Yet as the title suggests, this may not be 'the' Crucifixion, an unrepeatable historical event, but 'a' crucifixion, as though such things happen all the time. These figures wail and gnash their teeth at 'man's inhumanity to man' – appropriately enough, one might think, at a time when images of unimaginable horror were seeping out of Europe.

If this was war art, it looked like nothing produced under the official auspices of the War Artists' Advisory Committee, which was rarely more than softly modernist documentation of combat scenes, bomb sites or air raid shelters, effectively reassuring viewers that once this awful business was over, normal human

life – or something even better! – would resume. What lurks in Bacon's paintings is a sense that it is not just the 'enemy' that must bear the responsibility for the war's atrocities, but humanity itself. There was nothing reassuring about these three figures, identified later by Bacon as the Eumenides, or Furies, of ancient Greek tragedy who seek vengeance. Like the leeches they resemble, they want blood; and they come for us all. Bacon's paintings were displayed in the spring that the concentration camp at Bergen-Belsen was liberated. They seemed to say that nothing would ever be the same again.

It was hard, in the context, not to see Bacon's triptych as an 'obscene expression of the age'. But according to the artist, his triptych had nothing to do with the war. He had been experimenting with figures like this (as had de Maistre) since seeing Picasso's biomorphic drawings of the late '20s. The anguish was not that of the war, he said; it reflected private feelings of his own. We don't really know what they were. But we do know that he associated the three figures with the weird Eumenides of *The Family Reunion*, the play by T. S. Eliot that Bacon had seen with Eric Hall. In this play, a son who believes he has sinned returns to the family home but is pursued by Furies, interlopers from Aeschylus, whom nobody else can see. Perhaps Bacon's private torment converged with the world's at the point at which the *Three Figures* was shown. Despair was in fashion at the end of the war, as the art historian Andrew Brighton points out. The coincidence, if that is what it was, sealed Bacon's reputation. The triptych remains perhaps Bacon's best-known work, and went on to spawn its own progeny in the form of the famous 'chestburster' in Ridley Scott's 1979 film *Alien* (see below).

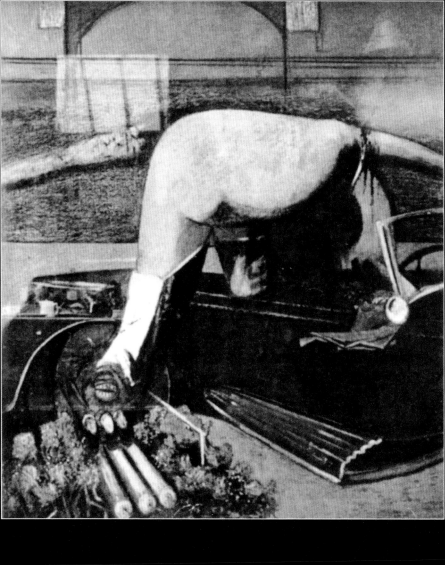

Figure Getting Out of a Car
Francis Bacon, c. 1939–40 (later reworked)

Original photographed by Peter Rose Pulham, 1946

Nazis

Bacon got uncomfortable when interpretations began to close in too tightly around his paintings. If he downplayed the importance, for his work, of the war, it was surely so as not to take on the role of 'war artist', with its didactic and moral implications. His painting, he insisted, was not a 'comment' on anything, did not have anything 'to say'. It did not, like Picasso's *Guernica*, for instance, counter barbarity with humanity. Barbarism was simply a human fact for Bacon. His view was bleakly post-humanist at a time when most intellectuals still clung to humanist ideals.

He was clearly drawn to fascist imagery. He collected photographs of Nazi architecture, Nazi rallies and Nazi figures themselves: in procession, addressing crowds from balconies and podiums, their mouths open, one arm stretched in fascistic salute. He was intrigued by the coincidence of the hectoring voice and the soft place – the mouth – from which it came, while the architectonic arrangement of Nazi spectacle gave him ideas for compositions.

Elements from this imagery found their way into many of Bacon's paintings of the 1940s, some of which have been lost or destroyed. *Figure Getting Out of a Car* was painted during the war, and was reworked into another painting, yet a photograph of the original picture remains (intriguingly the photograph includes reflections of a window and a tea-set from Bacon's Cromwell Place studio). Bacon suggested the painting derived in part from a photograph of Hitler getting out of a car at a Nazi congress. In Bacon's painting a weird biomorph, much like the figures in the 1944 triptych, leans creepily out of an open-topped car and seems to speak through a toothy mouth into a bank of microphones, which nestles amongst flowers. The Nazis liked flowers, especially at photo opportunities. A number of Bacon's paintings from the mid '40s embed the sense of a fascistic threat amongst aspidistras, tweed suits and leafy gardens, as if to refuse to the most apparently benign of things any kind of reassuring, let alone redemptive, role.

Hitler greeting the crowds at Nuremberg, 1933.
Lithograph, private collection.

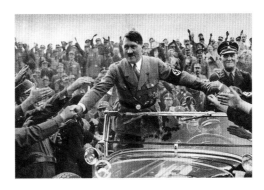

Painting (1946)

Like a scene from a nightmare, *Painting* (1946) is packed with significant objects and images, forced together incongruously for maximum impact. The nightmare is History. At the centre of the painting is a man in a dark suit under an umbrella; we can't see most of his face. He has the presence of a dictator, like those in the photographs Bacon collected. He is sitting in what Bacon called 'an armchair of meat'. Behind him hangs a carcass. A strange garland loops its way across the top of the image. It seems to be made of laced vertebrae, like bunting at a cannibal's tea-party.

There are plenty of echoes here from Bacon's image bank, only some of them identifiable. The hanging carcass recalls paintings of a similar subject by Soutine and Rembrandt; it suggests a Crucifixion. The garland is like one that adorned the balcony from which Hitler addressed the crowds in 1938; the drawn blinds are taken from a photograph of the dictator's bunker. The odd curved rails that appear in the foreground recall the metallic tubular frames of Bacon's interior design days. They would reappear in many other works as a vaguely fetishistic apparatus, which Bacon said was meant to 'lift the image outside its natural environment'. Characteristically he always insisted such devices were purely formal, but it is impossible to ignore their resonances in the real world – their similarities to the rails of cages in a zoo, for instance, the rail barriers around roulette tables, or rails at a race track (familiar to Bacon from childhood).

In retrospect the painting looks rather overdetermined, an index of what would one day be seen as Baconian imagery crammed together in almost parodic fashion. It was one of Bacon's favourites, however. He liked it, he said, because it was a good example of how a painting could come about by chance. He began by painting an ape in grass; the image morphed into a bird alighting in a field, until 'a series of accidents mounting on top of each other' resulted in the work we see now.

It was through *Painting* (1946) that Bacon acquired a dealer – it was bought by Erica Brausen in the year in which it was painted. Two years later it was bought by the Museum of Modern Art in New York.

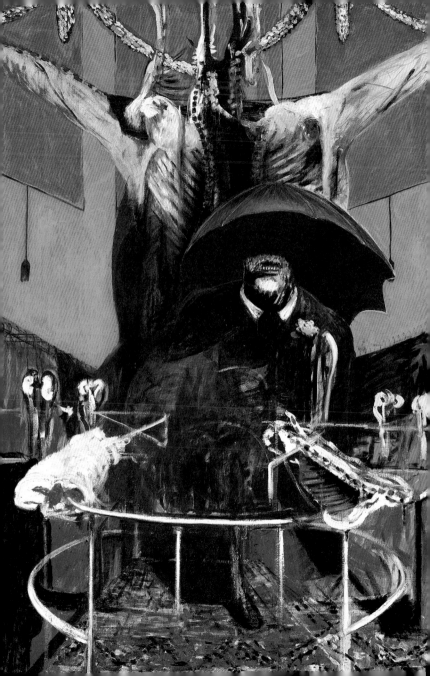

Heads

In 1949 Bacon exhibited a series of six paintings called *Heads*. Here is what the French philosopher Gilles Deleuze described as a 'zone of indiscernibility', where human and animal merge. We are looking at heads, for sure, without the reassuring prominence of the *face* that we have come to expect from portraiture. Very prominent in every case is the mouth, the most bestial part of a head; Bacon seems to have taken this directly from a photograph of a chimpanzee with its mouth wide open, showing its teeth as chimps do when threatened or frightened. Bacon wanted to 'make the animal thing come through the human'. As Deleuze pointed out, this was not a 'lowering' of man to beast, but more disturbingly the identification of a zone of non-discrimination between the two.

Head II was the first time that Bacon experimented by painting on the unprimed side of a canvas. It gave him a dragging sensation he liked, and he continued to do it for the rest of his career. He said at the time that he wanted 'to paint like Velázquez but with the texture of a hippopotamus skin', an appropriately surrealist formulation of the sort of pastiche mixed with iconoclasm (as critic Lawrence Gowing put it) he was beginning to master. And then there are some of the weird, fetishistic elements that would evolve into Bacon's trademarks: a tiny white arrow, tentatively placed; background curtains depicted in vertical stripes, and ornamented with a safety pin. The uncompromising critic Wyndham Lewis was impressed by the show of *Heads* in 1949. But according to the *Times* critic, it was 'worse than nonsense'.

The extremity of these reactions is significant. Bacon certainly had genius but he still didn't really know how to paint; it was all a bit hit-and-miss. 'Part of the intensity of [Bacon's] paintings up to the mid-1950s is that they hover on the edge of incompetence', writes the critic Andrew Brighton. Bacon's task was to keep his painting from looking like 'the work of an under-trained painter working from photographs, which is what he was'. Somehow – and this was part of his genius – Bacon managed it; or more to the point, he managed to turn what could have been a handicap into raw originality.

Popes

Bacon was obsessed by a painting he had seen only in reproduction, Velázquez's 1650 portrait of Pope Innocent X. He had what he called a 'crush' on the image, which he described as 'one of the greatest paintings in the world', saying that it opened up 'all sorts of feelings' for him. The portrait fused with other images on which he was equally fixated. One of these was the screaming face of the nurse in Eisenstein's film *Battleship Potemkin* (see page 13). Another was Nicolas Poussin's *Massacre of the Innocents* (1629), a painting he saw at the chateau near Chantilly in 1927, and which contained what he called 'the best human cry in painting'. And then there was a book on diseases of the mouth that he had found in Paris.

Popes and screams should not go together. The instinctual human – akin to an ape – breaks rudely through the surface of the civilized human, decked out in the pontiff's regalia. The Pope is not, it turns out, immortal or inhuman. It's like seeing the Queen scream. He grips on to the arms of his pontifical chair and screams through a sort of black curtain into which he seems to be dissolving. Is he scared? Grief-stricken? Gasping for air? The face, with its wonky broken glasses, is that of the *Potemkin* nurse.

'You could say that a scream is a horrific image', Bacon told Sylvester. 'In fact, I wanted to paint the scream more than the horror.' He liked the 'glitter and colour that comes from the mouth,' he said, and 'always hoped in a sense to be able to paint the mouth like Monet painted a sunset.' Later, Bacon felt that his *Popes* had not been successful, being little more than 'distorted records', and rather silly. When he visited Rome he did not go to see Velázquez's great work. He was fearful of seeing the reality of it, he said, 'thinking of the stupid things one had done to it.'

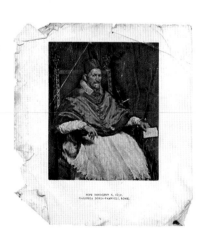

Reproductions of Diego Velázquez's *Pope Innocent X*, c. 1650.

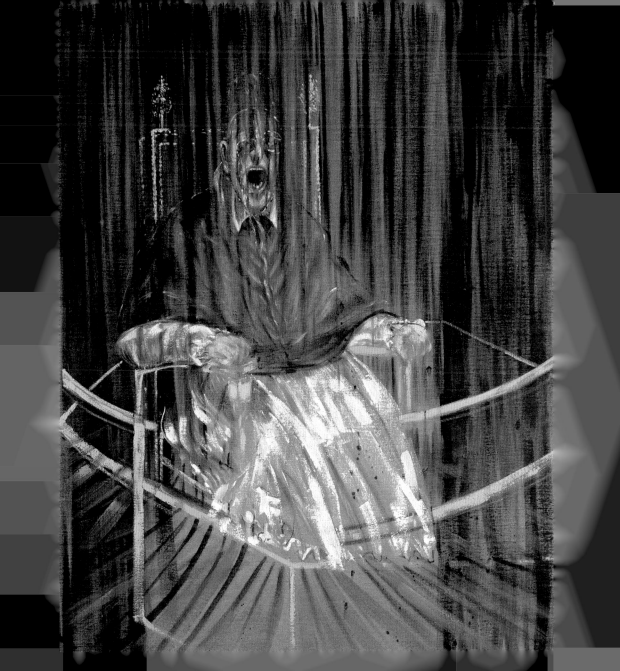

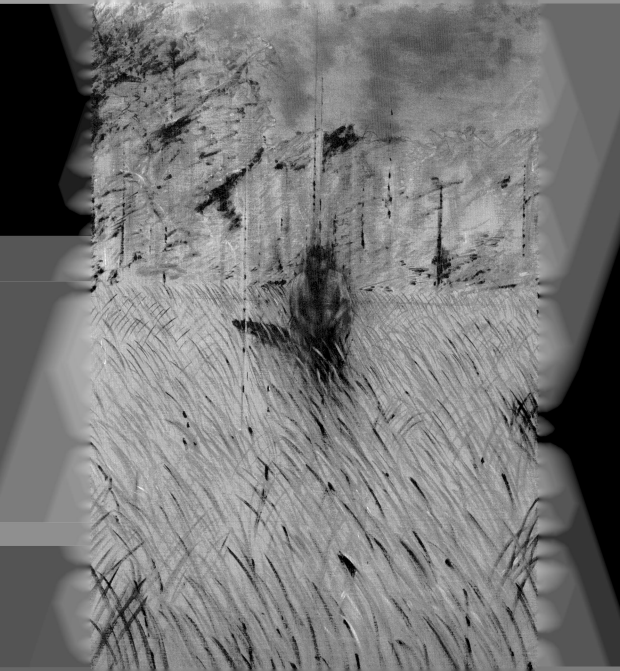

Peter Lacy

By 1952 Bacon had embarked on a destructive and all-consuming love affair with a former Battle of Britain pilot called Peter Lacy. Lacy was sadistic and an alcoholic; Bacon liked the association of sex with pain, and later said he was the love of his life. Lacy had what Bacon's biographer Andrew Sinclair called the 'damaged respectability' and 'distorted façade' that the painter loved. He appeared to be polite, shy and gentlemanly. His gentility, though, was only superficial. Lacy invited Bacon to live with him in his cottage at Hurst in Berkshire, where, he said, he could sleep and shit on straw and be chained to the wall. Bacon did not accept the offer, but did spend a lot of time there in the early '50s.

Lacy disliked Bacon painting, and would often destroy his work during their many rows; *Study of a Figure in a Landscape* survived these destructive rages. It appears to show Lacy, naked, crouching in grass. But this is no return to nature: the juxtaposition of naked human animal and wild grass is incongruous. The man squats as if lying in wait, or hiding; it is unclear whether he is hunter or hunted. The body's blurriness (against the grass's clarity) recalls images of big game hunting, and there's a sense of a landscape that is scanned – through binoculars, or a gun's viewfinder – for signs of life. It's a rude scene, charged with the presence of ambiguous instincts on the part of both the observer–painter, and the observed.

Men in Blue

Gay life in Britain came under the microscope with the 1957 publication of the Wolfenden Report, which recommended that homosexual acts between consenting adults in private should be decriminalized. Only in 1967 did homosexuality become legal. Bacon liked it the way it was before. He preferred to consider his sexuality to be a perversion, potentially punishable by law. He enjoyed the criminal aura of an activity that had been forced underground. Queer men had to live something of a double life; this juxtaposition of public veneer and private reality, which infuses so many of Bacon's paintings, excited him, speaking as it did of a broader sense in which civilized life is in any case little more than a membrane covering animal feelings.

In 1954 Bacon was working on a series of paintings all called *Man in Blue*. According to the artist, they were based on a businessman he met at the Imperial Hotel in Henley-on-Thames, where he stayed for a while during his relationship with Peter Lacy. In a letter he told David Sylvester that he was working on a series 'about dreams and life in hotel bedrooms'.

It's hard to describe these images, or the atmosphere they create. The sense that they are reminiscent of the films of David Lynch reflects the fact that Bacon's works were an inspiration for them. The seven surviving paintings are fields of dark blue, each showing a man in a suit and tie, sitting at a table, or leaning against what seems to be a bar, boxed in using Bacon's habitual 'framing' or 'caging' device. Somehow the man – who consists of a minimum of brushstrokes – conveys a sense of extraordinary tension and solitude; in other paintings of similar men, Bacon shows them screaming or collapsing.

We don't know if the man from the Imperial Hotel was an anonymous liaison of the artist, although there are hints that he was, and Bacon did have a preference for such straight-looking men. It doesn't really matter. There is something about both the subject matter and the application of paint, that suggests the coexistence of multiple realities (Lynch again), and that most ancient of themes, the skull beneath the skin – and the fleshly man beneath the suit. There's a mysterious equivalence of paint and flesh here that Bacon held to be key to the medium. But like all of his best works, the *Man in Blue* paintings are affecting without it being possible to say why.

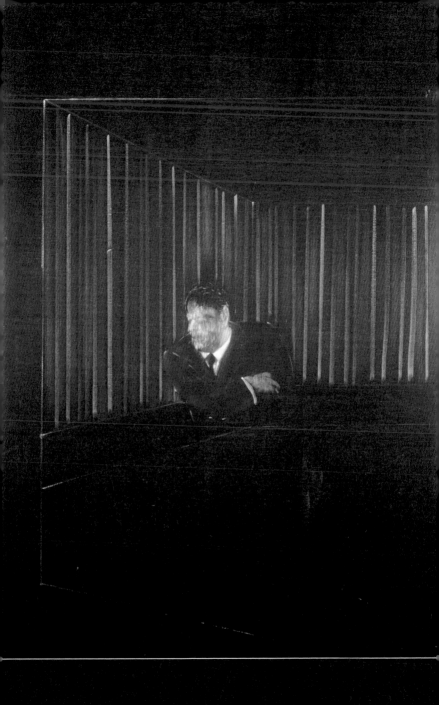

Man in Blue I
Francis Bacon, 1954

Oil on canvas, 198 x 137 cm (78 x 53⅞ in)
Museum Boijmans Van Beuningen, Rotterdam

Cages

Perhaps Bacon's most recognizable technique was to enclose his individual figures inside a sort of transparent 'box', whose edges are marked out by thin painted lines. Sometimes called a 'space-frame', sometimes referred to as a 'cage', Bacon's use of this box started in earnest in the late '40s and continued throughout his career. It has given critics something to think about. Many have given it an existential interpretation. It underlined the 'nightmarish incapacity' of Bacon's figures to 'come to terms with the world around them', sealing them into their own 'private hell', according to Ronald Alley. Others have pointed to the fact that the young Bacon was apparently often shut into a cupboard by his father, giving him both a fear of and an attraction to small spaces (he preferred to paint in a small room). Some point to the early works of the sculptor Alberto Giacometti – of whom Bacon was a great admirer – as inspiration. The lines also recall the grid used as a background in the photographs of Eadweard Muybridge, with which Bacon was somewhat obsessed.

Bacon himself gave a strictly formal explanation for his use of the device. He did it to cut down the scale of the canvas, he said – to concentrate the image down and to see it better. It was not supposed to 'mean' anything else; it simply served as a frame. Of course, Bacon disliked analyses of his paintings that ascribed fixed meaning to things. But when you read Nietzsche's description of the 'wretched glass capsule of the human individual', for instance – remembering that Nietzsche was one of Bacon's touchstones – it's hard not to think that something of this can be seen in Bacon's enclosed bodies.

Comparisons have been made between Bacon's 'space-frame' and the images of the trial of Nazi Adolf Eichmann in Jerusalem. Eichmann was questioned in a bullet-proof glass booth. There are photos of him wearing a suit and tie and speaking into a microphone that are remarkably like Bacon's *Study for Portrait* (1949), which shows a suited man seated inside a very clearly delineated 'space-frame'; he is screaming. Yet the Eichmann trial took place in 1961, some 12 years after Bacon's painting. It's not the only instance in which Bacon's images have been considered prophetic. For the writer Gordon Burn, Bacon's paintings predict reality TV shows like *Big Brother*, with their 'simultaneously claustrophobic and voyeuristically transparent spaces'.

Tangier

In the late '50s Bacon spent part of each year in the North African city of Tangier. The city was a Mecca for pleasure seekers, tax exiles, decadents and deviants of all sorts. In 1956 it became part of Morocco, but before that it was part of an International Zone that escaped the usual sorts of financial and legal regulation, making it a good place for smugglers, spies, gamblers, junkies and those looking for easy sex with young men and boys: the sex industry flourished here, relatively openly. It had also long been a destination for artists and writers, in love with the light and the freedoms. These included the writers Tennessee Williams, Ian Fleming, Paul Bowles, William Burroughs (who wrote *Naked Lunch* there), Jack Kerouac and Beat poet Allen Ginsberg.

In 1956 Peter Lacy moved permanently to Tangier, taking up the picturesque position of piano player at a drinking establishment, where his earnings were generally cancelled out by his tab at the bar. Bacon was still in love with this man, and he enjoyed the pleasures offered here. As a new arrival, Bacon himself was the object of interest to the resident literati. He might look like an English schoolboy, Ginsberg told Kerouac in a letter, but he has the soul of a satyr: he 'wears sneakers and tight dungarees and black silk shirts and always looks like going to tennis … and paints mad gorillas in grey hotel rooms drest [sic] in evening dress with deathly black umbrellas.'

When Bacon was in town, his relationship with Lacy continued much as it had in England, with the usual rounds of violence and destruction of paintings, exacerbated by Lacy's increasingly heavy drinking, and by the many casual liaisons had on both sides. The story is told of how the British consul-general in Tangier became concerned by the number of times Bacon was found beaten up on the city's streets in the early hours of the morning, and requested that more police be put on duty. A few weeks later it became clear to the chief of police that there was nothing to be done; as he told the consul-general, '*Monsieur Bacon aime ça.*'

Van Gogh

Bacon brought only one painting back with him from Tangier, *Pope with Owls* (1958). Nevertheless, the light and the landscape of North Africa found their way into Bacon's work. There's an explosion of colour, for instance, in the paintings he made in homage to Van Gogh, for a one-man show he was having at the Hanover Gallery in 1957. Bacon had long loved the work and writings of Van Gogh. He read and re-read the artist's letters to his brother, as well as the weird essay Antonin Artaud wrote about him. No doubt there was some kind of identification at work here. The image of the tortured artist – Van Gogh was the ultimate – was very much in vogue after the war, with Kirk Douglas playing the part of the artist in the 1956 film *Lust for Life*.

Van Gogh's painting *The Painter on the Road to Tarascon* had been destroyed during World War II, but was known to Bacon through reproductions. As such it was a sort of 'phantom' image – the trace of a physical object which no longer existed, a shadow of it. In the painting – a self-portrait – Van Gogh walks along a road carrying the equipment he needs to paint outdoors, his shadow oddly prominent as though it might have a life of its own. For Bacon the figure was 'like a phantom of the road', and so the dead artist in the lost painting was doubly phantasmic.

Bacon's versions of the painting are unlike anything he had done before, or would do again, with their bright blocks of primary colours. He did them, he said, 'because nothing else had gone right'. They were done in a rush, and delivered to the gallery with the paint still wet. They clearly came at something of a crisis point in the artist's work and life. The critic Lawrence Alloway – who had liked the old screaming heads – described the series as 'an outburst from a gypsy violin'. But for others, here was the painter at his most inventive, his most fearless. According to the critic Jerry Saltz, this was the last time that Bacon would be quite so bold.

The Painter on His Way to Work, by Vincent Van Gogh, 1888
(Formerly Kaiser-Friedrich-Museum, Magdeburg, later destroyed)
Oil on canvas, 48 x 44 cm (19 x 17¼ in).

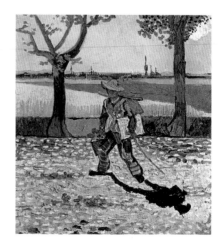

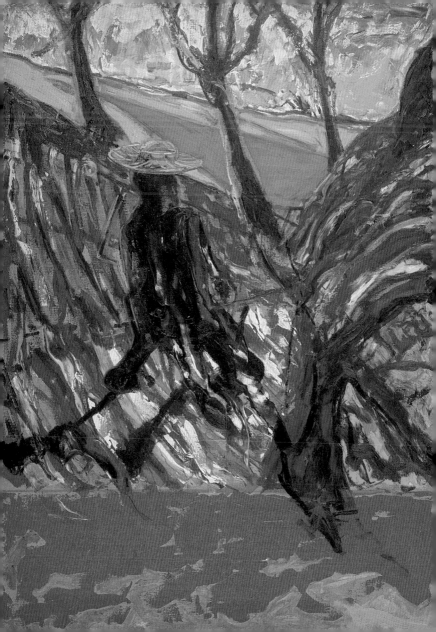

Reece Mews

In the autumn of 1961, Bacon took up residence at 7 Reece Mews in South Kensington, where he would live and work until the end of his life. His lodgings were poky and austere, but he found he could work there. A steep staircase, like a ship's, led to three rooms: a bedsitting room, a studio and a room that was both kitchen and bathroom. 'People think I live grandly,' he would say, 'but I live in a dump.' The minimal contents of 7 Reece Mews – the mattress on the bed, the bare light bulbs, the hanging light cords – would come to furnish Bacon's paintings like the props in a play by Samuel Beckett.

But it was the studio that was the most astonishing space. It was small, and famously messy. At one end there was the big round mirror from his interior design days, getting increasingly spotted as the years passed. Used paint containers and old rags piled up on every available surface, wedged between piles of books and jars and tins jammed full with used paintbrushes. Dust covered everything and was used sometimes in paintings. The walls and the door doubled up as palettes for mixing paint; the resulting unselfconscious smears of colour lent an air to the place that was both exciting and strangely abject. On the floor was the ever-growing layer of what Bacon sometimes referred to as 'compost'; books, catalogues, and piles of photographs and reproductions of paintings torn out of magazines or books. For Bacon it was a great deep sea of images out of which, occasionally, a particular image would surface as if by chance, perhaps giving him what he needed for a painting he was working on.

Characteristically, Bacon's living and working quarters combined squalor with luxury – or, to be more precise, the *squandered* luxury for which the artist had a penchant. He would make stock using vintage wine, for instance, and use expensive cashmere sweaters to rub paint on the canvas. When he became wealthier he bought other premises in which to live and work – bigger, lighter ones in which he could work on more paintings at a time – but he always returned here. 'I feel at home here in this chaos,' he would say, 'because chaos suggests images to me.'

Portrait of Bacon in his Reece Mews studio, 1967, by Ian Berry.

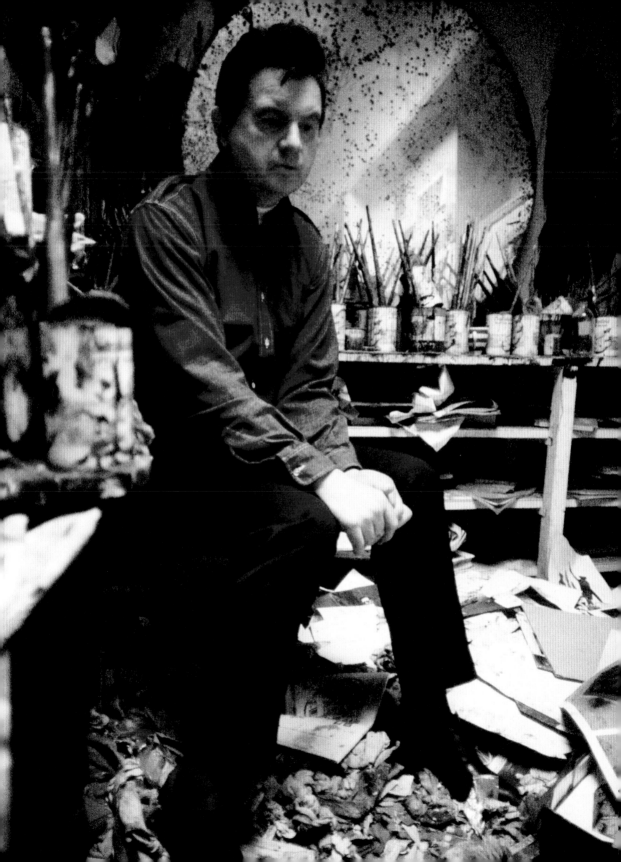

Soho

Bacon's capacity for drink, and his tireless sociability were legendary. At the end of a day's work (which might be at lunchtime) he would inevitably head to Soho, where good food, drink, casinos, conversation and sex of all kinds could be found. Soho's debauchery was thrown into relief by post-war austerity. Unlike the rest of Britain it was a good place to be gay. The social restrictions that governed so much of how people related to each other in British society did not seem to apply here. The risk was what the poet Tambimuttu called 'Sohoitis' – you might never leave, and never get any more work done. Unlike many of his drinking companions, however, Bacon never succumbed.

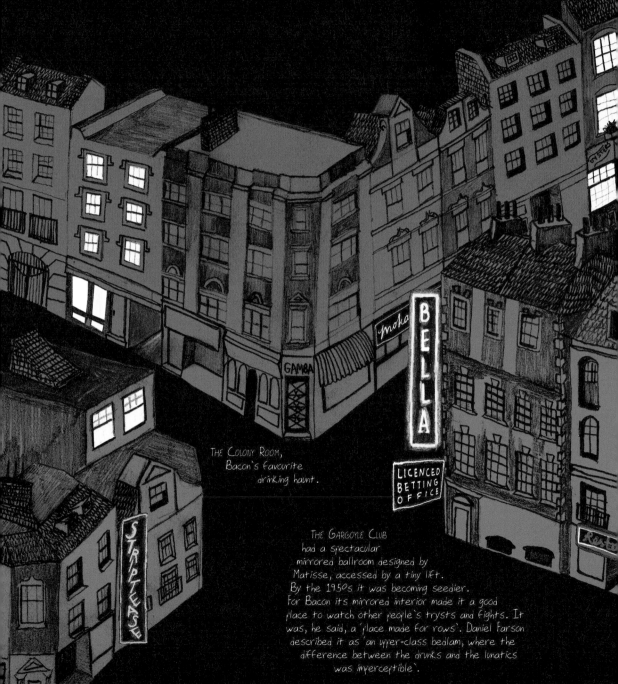

THE COLONY ROOM,
Bacon's favourite
drinking haunt.

THE GARGOYLE CLUB
had a spectacular
mirrored ballroom designed by
Matisse, accessed by a tiny lift.
By the 1950s it was becoming seedier.
For Bacon its mirrored interior made it a good
place to watch other people's trysts and fights. It
was, he said, a 'place made for rows'. Daniel Farson
described it as 'an upper-class bedlam, where the
difference between the drunks and the lunatics
was imperceptible'.

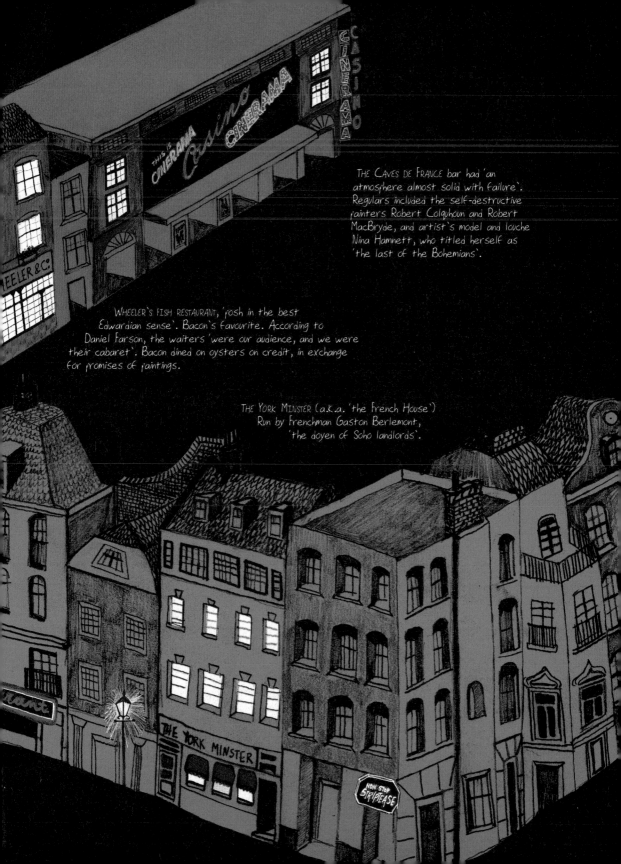

THE CAVES DE FRANCE bar had 'an
atmosphere almost solid with failure'.
Regulars included the self-destructive
painters Robert Colquhoun and Robert
MacBryde, and artist's model and louche
Nina Hamnett, who titled herself as
'the last of the Bohemians'.

WHEELER'S FISH RESTAURANT, 'posh in the best
Edwardian sense'. Bacon's favourite. According to
Daniel Farson, the waiters 'were our audience, and we were
their cabaret'. Bacon dined on oysters on credit, in exchange
for promises of paintings.

THE YORK MINSTER (a.k.a. 'the French House')
Run by Frenchman Gaston Berlemont,
'the doyen of Soho landlords'.

Three Studies for a Crucifixion
Francis Bacon, 1962

Oil on canvas; each panel 198.1 x 144.8 cm (78 x 57 in)
Solomon R. Guggenheim Museum, New York, Museum no 64.1700

Crucifixion

In 1962, despite some reservations from the gallery's trustees, the Tate decided to hold a retrospective exhibition of Bacon's work. It was quite an honour. Bacon worked furiously on a number of big paintings in preparation for the show. The triptych *Three Studies for a Crucifixion* was done in a fortnight, 'under tremendous hangovers and drink', he said. It was a deliberate revisiting of his early successes, *Three Studies for Figures at the Base of a Crucifixion* and *Painting (1946)*. The paintings were done roughly, out of a sort of despair, he said, but the results pleased him. The images produced under these conditions sprang unbidden and unchecked from some sub-rational realm. He could not say what they were, exactly, or what they meant.

Neither could the critics. Perhaps the central painting was a Deposition scene, where – in the traditional Passion – the body of Christ is taken down from the Cross. Perhaps, thought one critic, holding fast to their art-historical training, the figure on the right was St Peter, who was crucified upside down. But what were those two figures in the left-hand panel doing? When asked, Bacon supposedly said they were Himmler and Hitler opening the doors of the gas chambers – but later denied it. He disliked narrative interpretations of his paintings. But he did tell David Sylvester that the figure in the right-hand panel was something he'd wanted to do for a long time. It derived from a Crucifixion scene by the thirteenth-century painter Cimabue, in which the downward undulations of the crucified Christ made Bacon think of a worm crawling down the Cross.

It also looks very much like a side of meat hanging in a butcher's shop. Bacon associated Crucifixion imagery with photographs he had seen of slaughterhouses, images he was very moved by (these may have been the ones that accompanied Georges Bataille's essay on slaughterhouses in the Surrealist magazine *Documents*). He always associated meat with mortality, and thought about his own when walking in Harrods Food Hall. In the central panel of this triptych the body is little more than a pile of meat on a bed, which was ultimately the way in which he saw it.

When asked why he – a non-believer – had made the Crucifixion his subject, he described it as 'just an act of man's behaviour, a way of behaviour to another'. As such, and as a painter's theme with a long, long pedigree, the Crucifixion offered him 'a sort of armature' on which he could 'hang all sorts of feeling and sensation'. It was also a way of raising a central figure above others, which, for Bacon, offered great formal possibilities.

Eadweard Muybridge

Bacon's most enduring photographic obsession was with the work of the Victorian photographer Eadweard Muybridge. Muybridge pioneered the photography of movement. Famously, it was his photographs of galloping horses that showed artists that they had been painting them wrongly for years. Muybridge, like Bacon, saw humans as a particular sort of animal. His 1887 portfolio *Animal Locomotion: an Electro-Photographic Investigation of Consecutive Phases of Animal Movements* included sequences of images of humans doing things like walking, fencing and wrestling, as well as photographs of zoo animals pacing and birds in flight.

Bacon used Muybridge as a visual resource. For a figurative painter who never (as far as we know) attended a life class, Muybridge provided useful reference material for anatomy – indeed Bacon claimed Muybridge and Michelangelo were 'mixed up in my mind together'. Muybridge's photos also generated ideas. Bacon extracted the strangeness of Muybridge's pre-cinematic project, with its oddly lonely figures endlessly engaged in their mundane activities. Some of these figures appeared repeatedly in Bacon's paintings: the wrestlers who could be lovers, for instance, and a child disabled by polio walking on his hands and feet.

Two Muybridge figures are combined in a painting from 1965. The woman and the child, naked and animal-like, are perched on a circular rail, causing one to perceive that they must have unusually prehensile feet. It's as though they are condemned to perambulate the circle endlessly for no apparent purpose. They are perched over and around a void; there is nowhere else to go. It's as if the closed circularity of the actions of Muybridge's figures – a necessary corollary of his project – has been extrapolated into an allegory of what, for Bacon, was the absurd pointlessness of life: we walk a circular rail over a void. Typically for Bacon's work from the 1960s, there's a much brighter palette here, perhaps showing the influence of the colours of man-made textiles and other materials that were becoming fashionable at that time.

'Infantile paralysis; child walking on hands and feet', plate 539 from Muybridge's *Animal Locomotion*, 1887. Victoria and Albert Museum, London

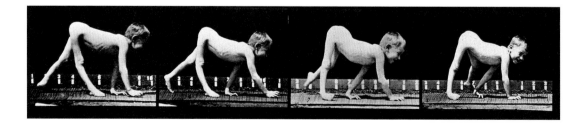

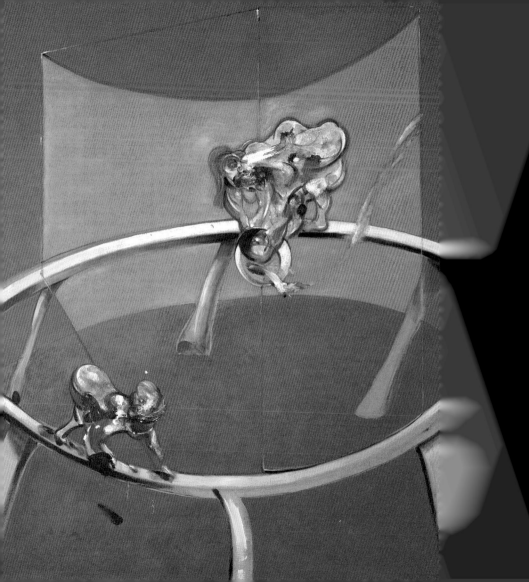

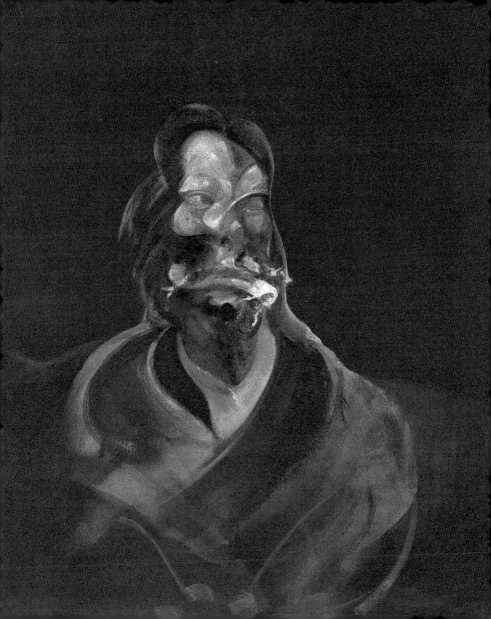

Portraits

In the 1960s and '70s, Bacon turned increasingly to portraiture. His subjects were people he knew well, on the whole – Lucian Freud, Henrietta Moraes, Isabel Rawsthorne, Muriel Belcher. The fact that he knew them so well meant he did not need them to be there when he was painting them – he preferred to rely on memory, and on photographs.

Painting a portrait was for Bacon very much wrapped up with *chance*, the accidental mark or fortuitous stroke that somehow locked in the likeness and created an image that was worth keeping. It could not be done deliberately. 'My ideal,' he said, 'would really be just to pick up a handful of paint and throw it at the canvas and hope that the portrait was there.' Neither was it a matter of reproducing – even by accident – a person's appearance exactly, as a photograph might. The portraits he made famously distort their subject's features so that they are sometimes almost unrecognizable as a person, let alone as a particular individual. The aim was to remake a fuller sense of likeness precisely by destroying appearance; to pin down the real person with a precision belied by the apparent chaos of marks. It was a question of avoiding illustration again, a way of bypassing the intellect and going straight to the nervous system.

When asked why he preferred to do portraits without the sitter present, Bacon said – perhaps disingenuously – it was to protect them from the violence he practised on them when he painted them. He had certainly had bad experiences of painting from life, and to commission, as most portrait painters do. In 1960 he agreed to paint a portrait of the society photographer Cecil Beaton, and was fairly pleased with the result. Beaton, however, was horrified. 'The face was hardly recognizable as a face,' he wrote, 'for it was disintegrating before your eyes, suffering from a severe case of elephantiasis: a swollen mass of raw meat and fatty tissues.' Aware of his sitter's distress (and no doubt indignant), Bacon destroyed the painting rather than asking him to pay for it.

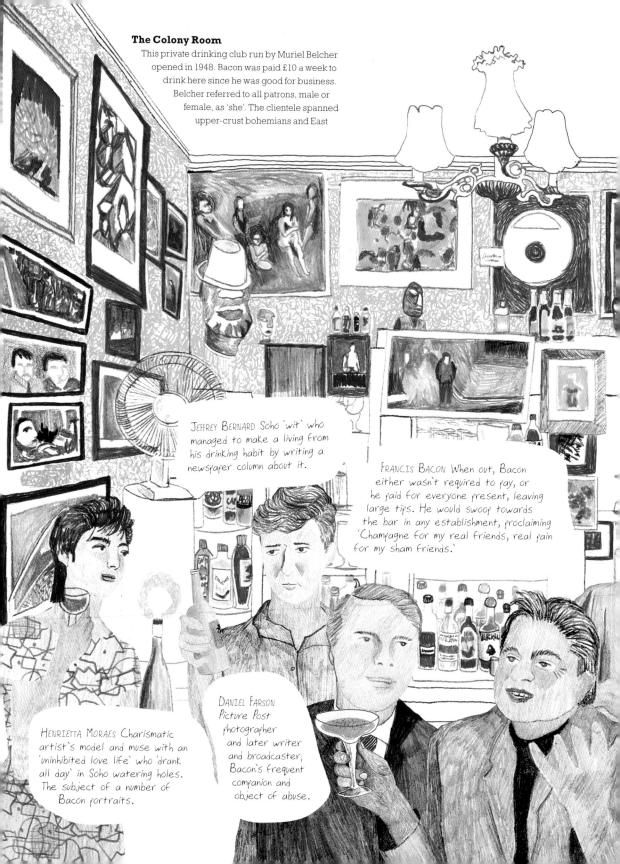

End muscle, and included cat burglars, war heroes and self-styled 'losers'. The artists who frequented the club became known as 'Muriel's Boys', and included Lucian Freud, Frank Auerbach and

Michael Andrews, as well as Bacon. Belcher would eject bores, but was kind to those she liked. She created a place where, as Bacon put it, 'you can lose your inhibitions'. The artist John Minton described going there like 'being in an enormous bed, with drinks'.

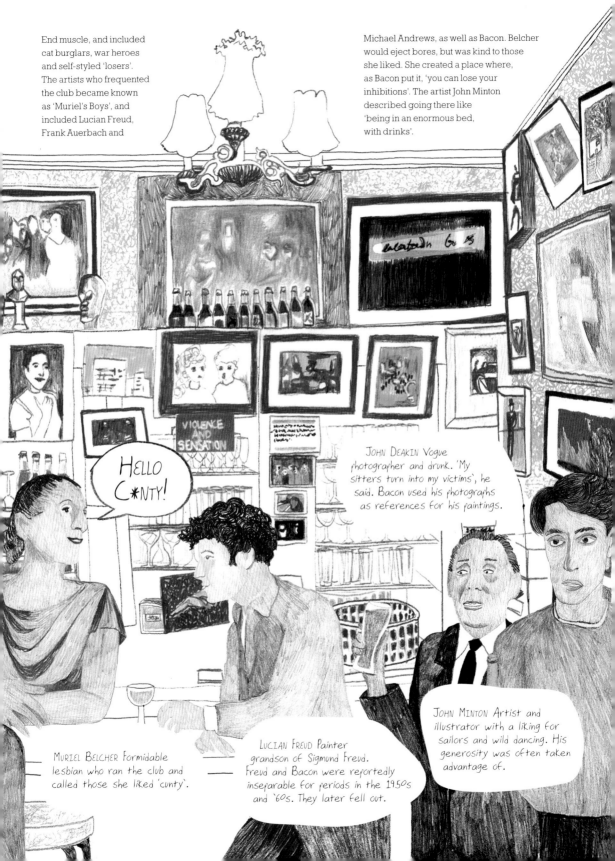

Henrietta Moraes

Lying Figure is one of a series of portraits Bacon painted of his friend Henrietta Moraes, based – at least in part – on photographs taken by John Deakin at Bacon's request. Moraes lies naked on a bare mattress, like the one in the central panel of *Three Studies For a Crucifixion*. Her face and body are a mess. Much clearer are the mattress ticking, the light switch, the hanging light bulb, the ashtray. These are the sorts of elements Bacon increasingly used in his painting for what he said were formal reasons. He included them to 'arrest the eye'; they were 'visual rivets'. He gave a similar explanation for the presence of a hypodermic syringe in Moraes' arm, saying that he wanted a device to 'nail the flesh onto the bed'. It was not meant to imply that Moraes was a drug addict, or that this was a scene of drug use. It's hard to see a syringe stuck in a person's arm in purely formal terms, just as it's hard to believe that Bacon thought it possible to paint a swastika on a figure's armband without people imagining he is meant to be a Nazi. It's another example of Bacon's desire to deflect narrative interpretations of his work.

The relative clarity of background and props stands in contrast to the distortion of the body in Bacon's work of this period. This became an abiding criticism of the artist. Robert Hughes, for instance, was disturbed by the 'extreme disjuncture' between the 'intense plasticity of the figures and the flat staginess of the rooms where they convulse themselves.' But the disjuncture between figure and setting suggests that the body is not something that can, or should, be depicted in the same way as something as stable as a mattress, a wall or a light switch. It implies that flesh is something of a different order. Flesh is not stable; it has a temporality that tends always towards death and decomposition. This was a fact that obsessed Bacon throughout his life. And it is a fact that photography – the predominant medium of the modern world – might imply, but is unable to represent.

Photograph of Henrietta Moraes by John Deakin, *c.* 1963.

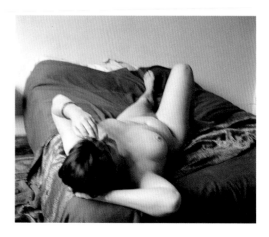

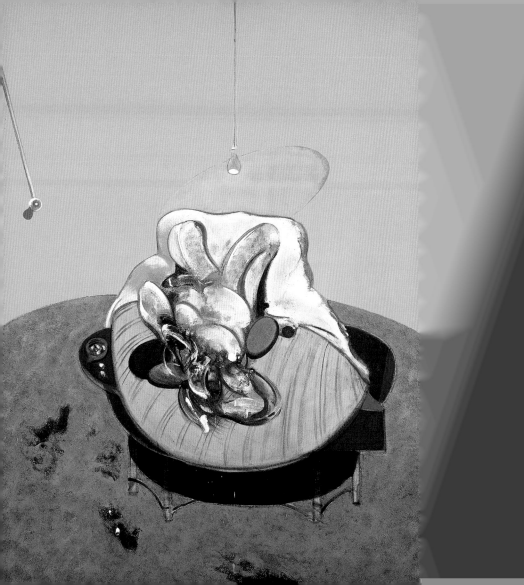

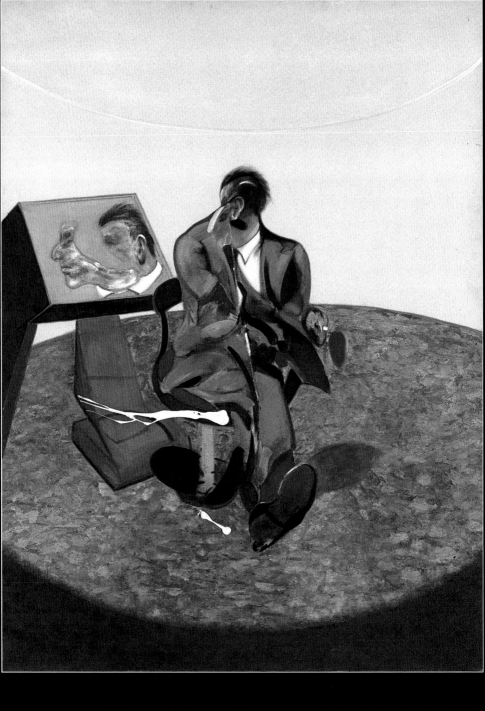

Portrait of George Dyer in a Mirror
Francis Bacon, 1968

Oil on canvas, 198 x 147 cm (78 x 57⅞ in)
Museo Thyssen-Bornemisza, Madrid

George Dyer

In 1963 Bacon met a man who would become the subject of some of his best, and best-known, paintings. George Dyer was a not-very-effective petty criminal from the East End. A weak character with a fit physique and a cleft palate, Dyer combined vulnerability with a gangsterish demeanour. Bacon described him as the most beautiful man he had ever met.

Bacon had Deakin take some photographs of Dyer – in profile on a Soho street, in his underpants in the artist's studio. These were endlessly reworked in the many portraits Bacon did of his lover. Most show Dyer doing mundane things: staring at a blind cord, riding a bike (he never did) or just sitting on a chair. Bacon was perhaps at his most experimental with these paintings – there are lots of puns on the act of looking at another person, and on the business of representing them. There are mirrors, shadows and reflections, pinned-up simulacra and odd little homunculi, offering images-within-an-image of portraiture itself. Many of these works are finished off (Bacon claimed it 'sealed' the image) with a spurt of defiling thick white paint. Painting and sex, the visual and the carnal; it's impossible to separate them here.

Portrait of George Dyer in a Mirror is exemplary. Dyer is sitting on an office chair, wearing his usual smart suit. His body is folded, like the photograph on which it was based; a white vertical line is where the crease falls. He is having a cigarette. The mirror beside him shows his face in profile – this is Deakin's photograph – but it is incomplete, torn. Dyer seems to be twisting round on his chair to see his reflection. What he sees in the mirror would not, of course, be the profile that we see, because he himself will have moved. But there's no stable likeness to be had anywhere here, and there's something faintly but humanly pathetic about both our, and his, attempts to find it. 'Even if you're in love with somebody, everything escapes you', said Bacon. 'You want to be nearer to that person but how can you cut your flesh open and join with the other person? ... So it is with art.'

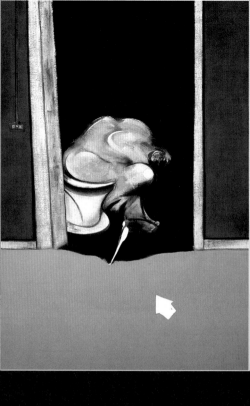

Triptych, May–June 1973

Francis Bacon, 1973
Oil on canvas, each panel 198 x 147 cm (78 x 57⅞ in)

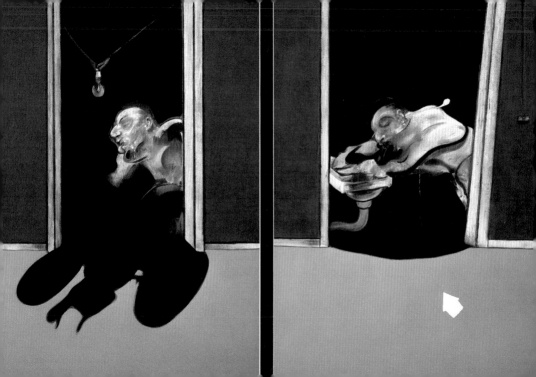

Paris, and Dyer's Death

In 1971 Bacon had an exhibition at the Grand Palais in Paris. It was a huge accolade. To be taken seriously by the French was a rare thing for a British artist, and Bacon was elated. Warned against it by his friends, he allowed Dyer to come along to Paris for the ride. George had by this point become something of a liability. He was financially and emotionally dependent on Bacon, and feared that he was losing his attention. Bacon was often cruel to him. The two fought a lot and drank too much. In Paris, Dyer's drinking got out of hand, and the pair fell out. The day before the opening of the show, George was found dead from an overdose in their hotel room.

The show – full of portraits of Dyer – was a great success. Parisian society was appalled and enchanted. On the opening night Bacon surprised everyone with his *sang-froid*. When David Hockney offered his condolences amidst the merriment, Bacon apparently shed mock tears, exclaiming 'you can only laugh or cry!' But Dyer's death, and feelings of guilt for his part in it, would obsess him for the rest of his life.

The tragedy also gave him possibly his best ever subject. *Triptych, May–June 1973* is one of a series of so-called 'black triptychs' that Bacon painted in memory of his dead lover, and the most explicit representation of his death. We see Dyer naked on the toilet (where he was found); we see him staring into air; we see him vomiting into the basin. Those familiar details of his being – his slightly hunched back, his slicked-back hair, the shape of his ear – all conjure up a real sense of George Dyer's presence, theatricalized in a way that only just avoids melodrama in the weirdly shaped shadow in the central panel.

Bacon said that by painting Dyer's death he wanted 'to get it out of his system'. But he also wanted to make a good painting, and he was, as ever, as much concerned about form as content. When art critic Hugh Davies first saw this triptych in Bacon's studio in 1973 it was work in progress. On his next visit he noticed that Bacon had begun to add the arrows that appear in the first and third panel. The artist explained that they took the emotional and dramatic edge off the work, and that he had got the idea from a book on golf instruction, where arrows indicated how to swing a club. There's a cruelty about those arrows, pointing as they do to scenes of such misery. They may take the edge off the drama, but they also register the cruelty inherent in looking at it; as we ourselves are doing.

After Dyer

There's an ancient story about the origins of painting in which a young woman traces around the outline of the shadow of her beloved's profile as it is cast on the wall. The image will be there when he has gone; it will still exist after his death. It's hard not to think of this story when considering the use Bacon made of Deakin's photograph of Dyer's head in profile, of which he had a number of copies. At one point he made a cut-out of this head and used it as a template, apparently pinning it to his canvas and painting around it.

Death if anything multiplied Dyer's appearances in Bacon's paintings, where his presence is often betokened by his distinctive profile, slightly animal-like, its nose pointing forward like one whose survival depends upon his sense of smell. In *Painting (1978)* Dyer's profile appears three times. The gesture of turning a key in the lock of a door was one that recurred in Bacon's paintings, though this one takes the image a weird step further by having Dyer turn the key with his toes. The image was associated in Bacon's mind with Picasso's bathers, and also with lines from 'The Waste Land' by T. S. Eliot: 'I have heard the key/ Turn in the door once and turn once only/ We think of the key, each in his prison/ Thinking of the key, each confirms a prison.' The late '60s and '70s saw Bacon turning to epic or literary themes, but he still discouraged reductive interpretations. At one point *Painting (1978)* included the word 'Eliot' in its title, but Bacon later removed it.

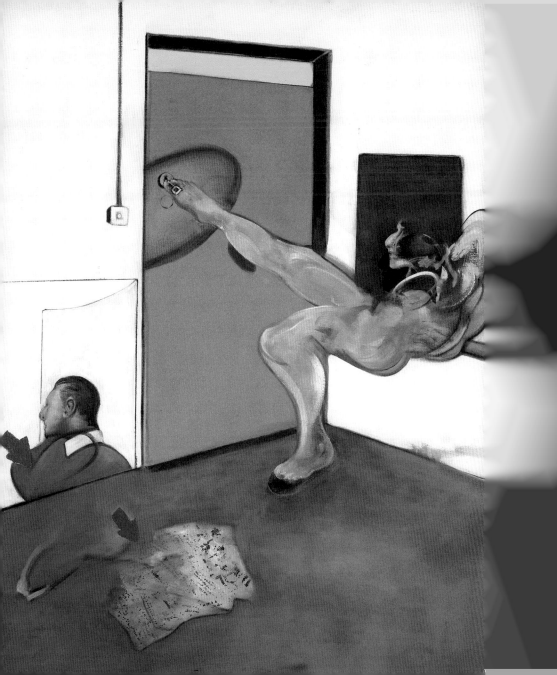

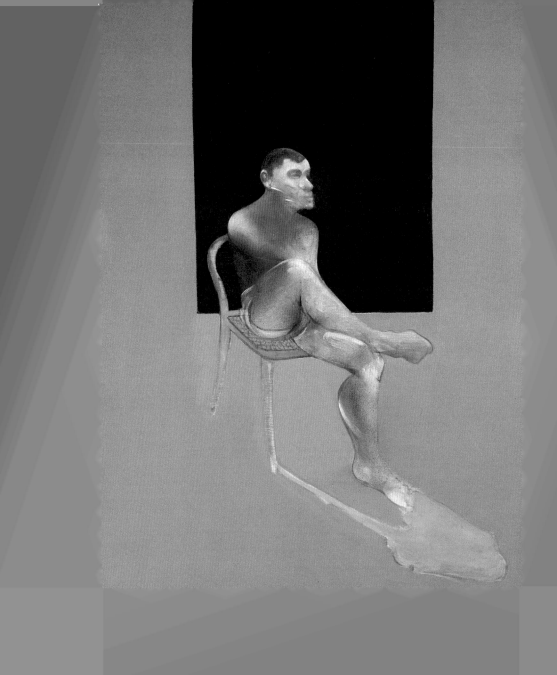

John Edwards

The works produced in the years following Dyer's death are dominated by guilt and reflections on mortality. Self-portraits produced in the early '70s show Bacon alone sitting on a chair. In these works the bare accoutrements of the room – sink and taps, light switch and hanging light bulb, the newspaper on the floor – seem to allegorize, as things, an existential pointlessness. Bacon claimed that he painted self-portraits at this point because so many of his friends had died or gone that there was only himself left.

In the mid-'70s Bacon met John Edwards, whose friendship (the two were never, apparently, lovers) brought a certain calm to the artist's life. Edwards was a pub manager in the East End who remained resolutely unimpressed by the world in which Bacon moved. Bacon looked upon him as a sort of surrogate son, and the 'only true friend' he ever had. They met most mornings for a fry-up breakfast at Reece Mews; Bacon would eat the yolk of the eggs, Edwards the white.

Edwards was the subject of a number of portraits in the 1970s and '80s. By this point Bacon's work was calmer, more assured. The flesh in *Portrait of John Edwards* consists not of dramatic gouts of paint but of gradated tones apparently created by spraying, giving the impression of bruising. The head and the profile of the face are definitely Edwards (although he couldn't understand why Bacon made him look like a monkey – a self-consciously philistine remark which Bacon found hilarious). The shadow of George Dyer remains, however. The seated pose of the body, the crossed legs, the white pants; these are all Dyer, as he was crystallized in Deakin's photographs. And the pinkish flesh-like shadow into which Edwards' body seems to segue was a device that Bacon used particularly in his paintings of Dyer after his death. The two outside panels of *Triptych* (1972) – one of the 'dark triptychs' – are almost exactly the same in composition and subject as *Portrait of John Edwards*, except that these depict Dyer, not Edwards; and Dyer, his eyes closed, seems to be literally disintegrating into his surroundings.

Landscapes

Bacon's subject had always been the figure, but in the late '70s and '80s he experimented with landscape. In 1973 he told Hugh Davies that just as he liked the anonymous compartments in train carriages, 'like a room concentrated in a small space', he wanted to paint a landscape in a box. Bacon had, of course, long been enclosing his figures in 'cages'. The idea here, he told Davies, was to enclose the infinity of a landscape or seascape in a box, so that they would 'have a greater concentration'.

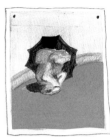

Sand Dune is one of the results of this experiment. An amorphous sand dune (apparently borrowed from a photograph on a French postcard) is enclosed in a box from which it seems to be attempting to escape. The dune resembles flesh, set loose from the controlling and ordering armature of the body, flesh without bones or consciousness, but perhaps with some kind of residual instinct. It was painted in a similar way to John Edwards' portrait, with Bacon adding dust from his studio floor.

Landscape was a new departure for Bacon. But *Sand Dune* features a number of elements that by now were familiar features of Bacon's work, and that risked becoming a habit (or 'little shrieks for help' as art historian John Richardson rather cattily put it). There's the arrow, the light bulb and cord, the ellipse on the floor that might be a circle of light. *Sand Dune* also features the hot orange that he used in his paintings of the 1940s. Increasingly, it seems, Bacon was trying to recapture something from his early days, whether it was as knowing pastiche or as a genuine (and possibly desperate) attempt to get back in touch with his early sources of inspiration and sensation. Bacon was engaged in a kind of cannibalization of his own oeuvre, including most obviously the *Second Version of Triptych 1944* (1988), a reworking of his first successful triptych. Reproductions of his own works snipped out of catalogues adorned the walls of his studio and kitchen at Reece Mews; his creation of images was becoming more and more self-referential.

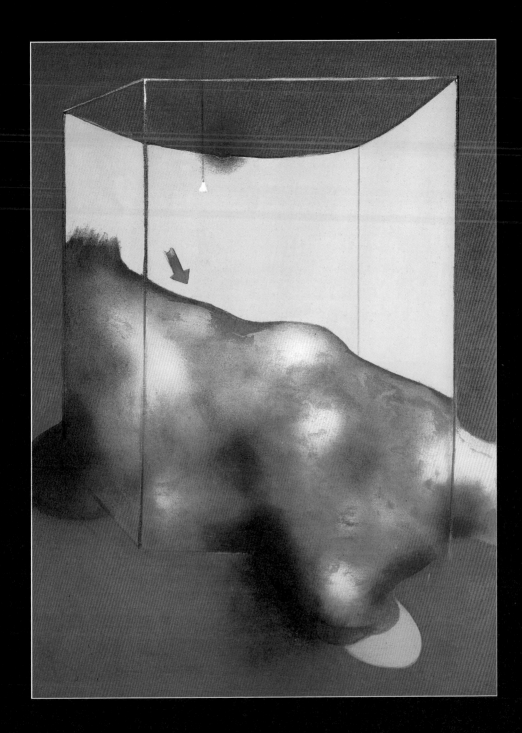

Sand Dune
Francis Bacon, 1983

Oil and pastel on canvas, 198 x 147.5 cm (78 x 58 in)
Fondation Beyeler, Basel

Bacon Mania

In some quarters, Bacon's star was still rising. In 1984 a Bacon exhibition in Paris was mobbed by fans, including a punk contingent. Bacon had acquired a sort of cult status in France. The words 'ONLY FRANCIS BACON IS MORE WONDERFUL THAN YOU' appeared on the wall of Serge Gainsbourg's house on the rue de Verneuil.

Bacon had by this point been granted the accolade of being *theorized* by the French. In 1981 the philosopher Gilles Deleuze published his remarkable tribute to the painter, *Francis Bacon: Logique de la Sensation*. Being written about by Deleuze, as critic Ben Davis wrote, gave Bacon a 'sheen of intellectual mystique'. Deleuze's text seems to wish to rival Bacon's paintings for visceral effects that are essentially not reducible to language, with remarks like 'the head-meat is a becoming-animal of man', or – slightly more graspable – 'the scream is the operation through which the entire body escapes through the mouth.'

By the end of the '80s Bacon's health was faltering. An affair with a much younger Spaniard revivified him for a while, but on a trip to Madrid in April 1992 he was taken ill and died of a heart attack. In his will he left everything to John Edwards.

Market

Bacon died a wealthy man. Money had always moved round him in a charmed way, a fact that was surely as much responsible for his famous 'charisma' as anything else. He treated money like it didn't matter much; and it responded by sticking to him like glue. By the end of his life his paintings were selling for very large figures. These figures sky-rocketed after his death, and continue to rise. In November 2013 the triptych *Three Studies of Lucian Freud* (1969) broke the record for a work of art sold at auction when it was bought for $142.4 million.

A subject of considerable controversy has been the apparent discovery, after Bacon's death, of drawings. Bacon always insisted that he did not, could not draw, and that he painted straight on to the canvas without bothering with preparatory sketches. It was part of the image of the artist as an inspired painter, driven by instinct and chance rather than an academic training which he did not receive. Yet many sketches have surfaced, including an astonishing collection owned by Barry Joule, Bacon's driver and handyman in his final years. Bacon apparently gave Joule this stash of sketches and doctored photographs as a gift; Joule, in turn, gave it to the Tate amidst much debate about how many of the images were from Bacon's own hand. In 2004 there was a trial in Italy to determine whether a further collection of late drawings – quite unlike any others known to exist – was really by Bacon as its owner claimed. The judge apparently ruled that the drawings had certainly been signed by Bacon, probably when drunk. Whether the drawings themselves are authentic is still a moot point, with much at stake financially.

Dublin Reconstruction

In 1998 the contents of Bacon's studio were donated by Edwards to the Hugh Lane Gallery in Dublin. Every object was removed and archived, its place in the great midden documented so that it could be meticulously reconstructed. This archaeological undertaking has been a spur to archival studies of Bacon's work, but the overall project runs the risk of fetishizing the artist's working space. Visitors to the Hugh Lane Gallery can contemplate Bacon's studio from a Perspex cubicle, before taking away, perhaps, a souvenir book of the photographs that were taken of just about every corner of Bacon's home before it was dismantled. There's a forensic, and somewhat voyeuristic, feel to the whole enterprise, as though we are inspecting the scene of a crime, or the home of someone whose particular pathology (hoarding newspapers, for instance, or the smearing of excrement) makes their rooms fascinating to others. We're invited to think we might be able to read something of Bacon's creativity or psychology from what he has left behind. Perhaps the idea is to invoke – through the Perspex – one of Bacon's paintings, with their isolating 'space-frames' and enclosure in glass. And it's possible to think, looking at the mess, that Bacon was not waving but drowning; that this is what he meant by his 'exhilarated despair'.

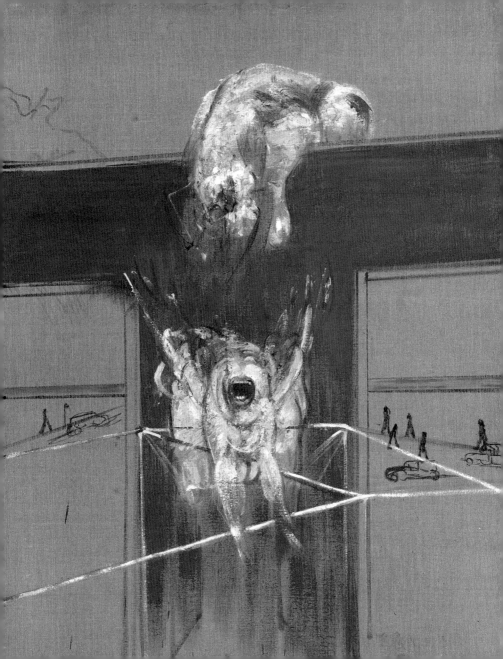

The Pain of Others

The Marxist critic John Berger disliked Francis Bacon's work because it offered no comment upon the anguish it portrayed. It was insufficiently indignant about 'man's inhumanity to man'. In an essay of 1972 he compared Bacon to Walt Disney. Both, he said, were essentially conformist; both suggest an alienation which we have no choice but to accept. Bacon might be a skilful painter, he wrote, but 'his progress ... is a technical one of getting the worst in sharper focus'. He had succeeded in making 'the worst' into 'more and more elegant art'.

Sure enough, in Bacon's paintings nobody objects: most often we see bodies in pain that is witnessed by no one, or passed by with indifference. In *Fragment of a Crucifixion* (1950) cars and pedestrians pass an astonishing scene of fear and torn flesh as though it were hardly worth noticing. Bacon later came to feel that this image was 'too explicit', too suggestive of a narrative. But in a way for this very reason the painting can be seen to dramatize most clearly a structure of pain and indifference that is there more subtly in other works.

In 2004 Berger changed his mind about Bacon. The artist had become relevant in a way that Berger had not predicted. The pitilessness of Bacon's vision had become the condition of the world (Berger was writing in the wake of the publication of the photos from Abu Ghraib; one can only imagine what Bacon would have made of *them*). To be sure, such a turnaround – on Berger's part – says more about the fate of idealism than it does about Bacon. Bacon, after all, had none of the illusions about human nature of progressive intellectuals. What is so devastating about Bacon's vision is its continuity – in art-historical terms – with the work of the Old Masters from which it borrows. The great humanism of the Renaissance, the redemptive prospects of religious art, the heroism of Classical art, all of these – as Berger writes – are shown to be 'powerless before the pitilessness'.

Bacon has always had fans, especially amongst the young. It started quite early. During a brief stint as a tutor at the Royal College of Art in 1950 he did no formal teaching (he did not believe art could be taught), yet his presence at the college had a powerful effect on a generation of students, for whom he was already a legend.

In popular culture Bacon's work has influenced film-makers like Bernardo Bertolucci, Peter Greenaway, Jonathan Demme and David Lynch (for whom he is 'the main guy, the number one kinda hero painter'). He is a hero, too, for so-called Young British Artists like Damien Hirst. Hirst collects Bacon paintings, and claims to watch them more than he watches TV.

Amongst critics, however, it has become common to question whether he was, in fact, any good. 'I vacillate between admiration and dismissal', wrote Adrian Searle in 2008. Sebastian Smee found Bacon's combination of brutal violence with 'immaculate beauty' irresistible as a teenager, but wondered if his early infatuation with the artist could stand up to critical inspection. He couldn't draw, after all, relying instead on charisma, powerful subject matter and what he called 'chance'. He was, in other words, a brilliant chancer.

For Hirst, unsurprisingly, this is part of the attraction. Another part of the attraction (especially, perhaps, for the young) is surely the lack of ambiguity. Bacon emerged from the cacophony of mass culture and the inheritance of the history of art with a clear and uncompromising view of human life without the customary veils. He recognized the mediating role of photography in particular, but it did not stop him from making an unqualified grand statement in paint. 'What modern man needs is a kind of shorthand', he told the students at the RCA. 'The bombardment of information to which we are constantly subjected should not overwhelm our capacity to receive it and render it down to a world-view.'

Francis Bacon
Neil Libbert, 1989
The image was taken on Bacon's 80th birthday, outside his studio in Reece Mews.
Bromide print, 34.3 x 23.1 cm (13½ x 9¼ in)

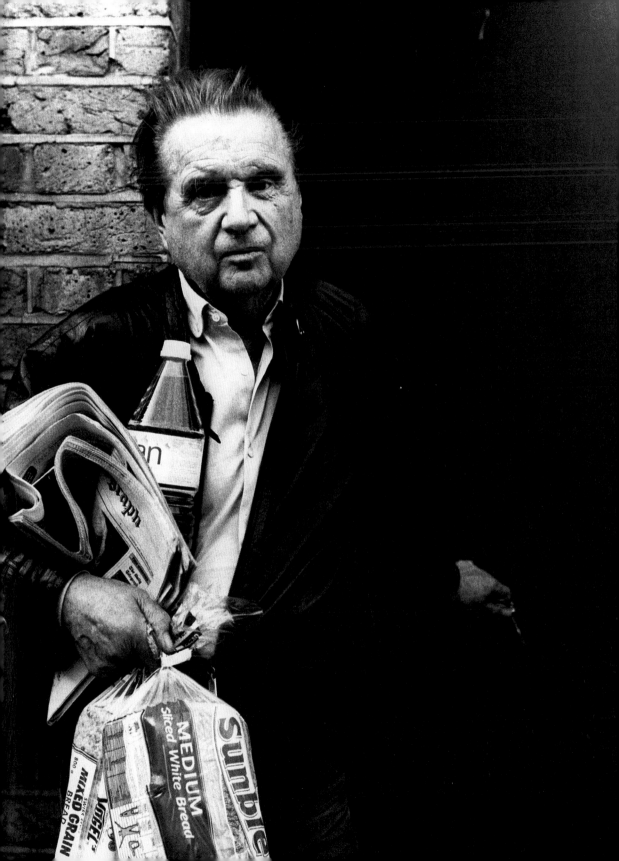

Acknowledgements

The author would like to thank Tony Bond, Martin Harrison, Margaret Hauser and Peter Wilson.

Bibliography

Dawn Ades and Andrew Forge, *Francis Bacon*
(Thames & Hudson, 1985)
Andrew Brighton, *Francis Bacon* (Tate Publishing, 2001)
Daniel Farson, *The Gilded Gutter Life of Francis Bacon*
(Century, 1993)
Matthew Gale and Chris Stephens, eds., *Francis Bacon*
(Tate Publishing, 2008)
Martin Harrison, *In Camera. Francis Bacon: Photography,
Film and the Practice of Painting* (Thames & Hudson, 2005)
Michael Peppiatt, *Francis Bacon: Anatomy of an Enigma*
(Constable, 2008)
John Russell, *Francis Bacon* (Thames & Hudson, 1971)
David Sylvester, *Interviews with Francis Bacon*
(Thames & Hudson, 1993)

Kitty Hauser

Kitty Hauser is the author of *Stanley Spencer*, *Shadow Sites: Photography, Archaeology and the British Landscape 1927–1955* and *Bloody Old Britain*. She has written for the *Burlington Magazine*, the *New Left Review* and the *London Review of Books*. After a research fellowship at Cambridge University, she taught at the Ruskin School of Drawing and Fine Art and the London College of Fashion, and now lives in Sydney where she writes a regular column for *The Australian*.

Christina Christoforou

Christina Christoforou is a London-based illustrator and artist. She started her career as an art director in Greece before relocating to London, where she gained an MA at Camberwell College of Arts. She has produced a poster of rock-star hairstyles and was commissioned by the *New York Times* to draw hair portraits of the Presidents and First Ladies. This is her first book.

Picture credits